Bottle trees

...AND THE WHIMSICAL ART OF GARDEN GLASS

Bottle trees

...AND THE WHIMSICAL ART OF GARDEN GLASS

Felder Rushing

PITTSBURGH

Bottle Trees
...And the Whimsical Art of Garden Glass

Copyright © 2013 Felder Rushing

ISBN-13: 978-0-9832726-9-4

Library of Congress Control Number: 2012940814
CIP information available upon request

First Edition, 2013

St. Lynn's Press . POB 18680 . Pittsburgh, PA 15236
412.466.0790 . www.stlynnspress.com

Book design–Holly Rosborough
Editor–Catherine Dees

Photographs © Felder Rushing

Printed in The United States of America
on triple-certified, FSC, SFI, and PEFC recycled paper

This title and all of St. Lynn's Press books may be purchased for educational,
business, or sales promotional use. For information please write:

Special Markets Department . St. Lynn's Press
POB 18680 . Pittsburgh, PA 15236

10 9 8 7 6 5 4 3 2 1

Dedication

This book is dedicated to gardeners with panache, who dare risk the ire of neighbors by flaunting colorful glass art in the garden, and to those of you who make bottle trees and other spectacular glass garden art for others.

Special thanks go the artists who let me into their studios and minds, including Stephanie Dwyer, Rick Griffin, Marcia Eames-Sheavly, Jerry Swanson, Andrew Young, and Jenny Pickford, all of whom have encouraged the use of glass in the gardens of countless gardeners. I thank the curators of the Eudora Welty Foundation for sharing her prose and photography, and the Corning Museum of Glass for allowing me to peruse their collection of ancient glass.

Introduction

First things first: There are two kinds of bottle trees – the living, tropical tree from Australia (Brachychiton) with its swollen, somewhat bottle-shaped trunk; and "yard art," made with glass bottles hung on trees or other supports.

This book is about the latter and its many spinoffs of glass garden art, ranging from homemade follies to high-end creations done by master glass artists.

For centuries people have used colorful glass in windows to bring color into the home (especially during dreary winter days). And, to the generation that grew up with

The other bottle tree

John Lennon singing about "cellophane flowers of yellow and green, towering over your head," it seems perfectly natural to take mama's colored glass from the windowsill on out into the garden as art.

What IS a Bottle Tree?

Bottle trees – often referred to as "poor man's stained glass" – are *joie de vivre* on a stick. They can be made by placing glass bottles onto branches

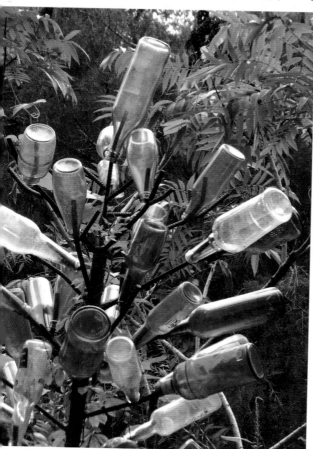

of dead trees or big limbs tied together, wooden posts with large nails, welded metal rods, rods pushed into the ground, or bottles simply stuck on the tines of an upended pitchfork. They are a concept, not a recipe.

Most loved by "bower bird" gardeners who lay out colorful enticements and bold statements about their individuality, garden glass adds a splash of outdoor color all year.

I once coined a pseudo-Latin moniker for bottle trees, Silica transparencii, for "clear glass" and even made up whimsical "cultivars" with names like 'Milk of Magnesia' blue and the mixed-color 'Kaleidoscope Stroke'. It was just one more poke-

Author's Garden, Mississippi

in-the-eye at folks who need to lighten up a bit. After all, lightening up isn't lowering your standards; it's just shifting an attitude, speaking a different language – same paradigm, different angle.

John Sledge, an editor from Mobile, Alabama, wrote that "like the dream catcher and the God's eye, the bottle tree is one of those folk expressions that have found traction in the broader culture." Best of all, as Bill Lipsey, a Mississippi Delta bottle tree maker says, "Bottle trees don't die! They never need water or fertilizer. Your bottle tree will always be in full bloom, 24 hours a day, 365 days a year!"

A Bit of History

The popular theory holds that bottle trees originated in the Congo area of 9th century Africa. Truth is, their lore is buried in ancient superstitions from farther north, invented and embraced by early Northern African and Arabian cultures.

Although Mediterranean cultures made glass objects as early as 3500 B.C., hollow glass bottles began appearing around 1600 B.C. Around that time, tales began to circulate that spirits could live in bottles – probably from when people heard sounds caused by wind blowing over bottle openings. This led to the belief that "bottle imps" could be captured in bottles.

The tale of Aladdin's lamp and its wish-granting genie originated as an Arabian folk tale dating back thousands of years, even before clear glass was invented. Before long, superstitious people started using glass to, as the stories go, capture or repel bad spirits. Their belief was that roaming night spirits would be lured into and trapped in bottles placed around entryways, and morning light would destroy them.

Apparently, the bottle imp/bad spirit belief was carried – along with glass bottles – down through sub-Saharan Africa as well as up into Europe, before eventually being imported into the Americas with the slave trade. Thomas Atwood, in his *History of the Island of Domi* (1791), wrote about

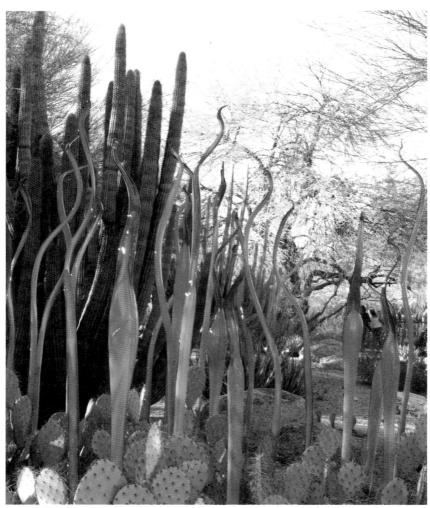

Dale Chihuly art glass, Desert Botanical Garden, Phoenix, Arizona

the confidence among Caribbean slaves in the power of "sticks, stones and earth from graves hung in bottles in their gardens."

Yet at the same time, Germans, Irish, and other superstitious European folk (who also put hex symbols on barns and celebrated May Day and Halloween) used reflective "gazing balls" and hollow "witch balls" to repel or capture witches and other supernatural spirits.

Beyond Bottle Trees

Now, designers all over the world embrace garden art made with glass, with an amazing assortment displayed in upscale garden shows, including the Chelsea and Hampton Court flower shows in London, and the international Floriade, which is held once every decade in the Netherlands. Most curated garden art exhibits now include garden glass creations.

That said, both "yard art" bottle trees and high-end glass sculptures are but simple variations on the same theme: glass deliberately placed in garden settings.

So don't get hung up on the what or how... just relax your mind and enjoy.

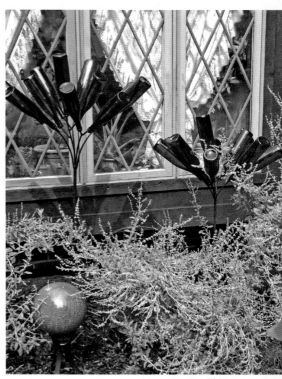

Youngstown, Ohio

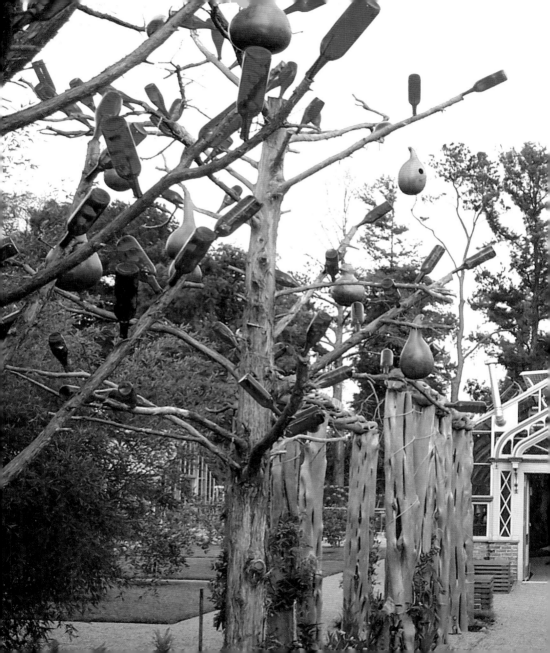

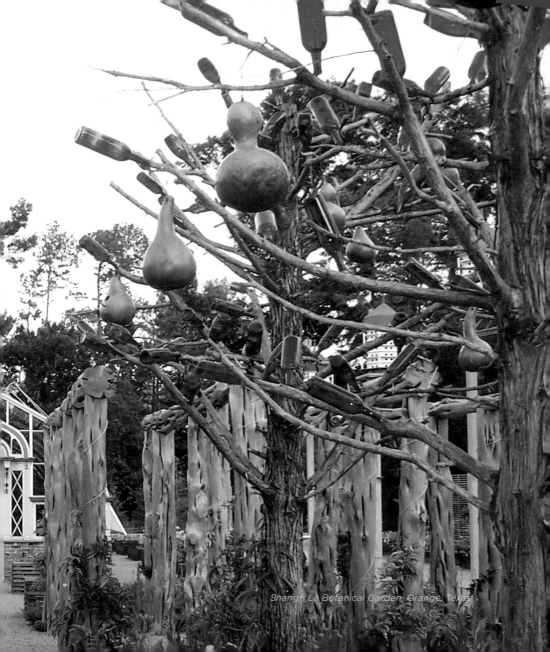

Shangri La Botanical Garden, Orange, Texas

Unforgettable

The first bottle tree I remember ever seeing – at least the first one anyone explained to me – was on a dusty farm road alongside the Sunflower River, which snakes through the heart of Mississippi Delta cotton fields where I was raised. I was fifteen years old, and the inexplicable, almost ridiculous ordinaryness of it haunts me to this day.

Some folks say a bottle tree is a forgettable sight; to me, that means they honestly just don't "get it." Because a bottle tree is usually unconventional, you might think the folks having one would be as well. Not necessarily; they just have a different take. They have an urge to do something artistic, but on a very personal level.

What I know for sure is that, like reflective orbs festooning childhood Christmas trees, the vivid colors of glass hanging in trees take me back to the magical days of an innocent but wonder-filled youth.

That day when I saw my first one, something in me shifted a bit. Looking back, it may have bent me somehow, ensuring on some level that my own garden could never be the same without one.

"THOSE WHO ARE SUPPOSED TO GET IT, WILL."

Joel Hodgson, creator of the cult TV program Mystery Science Theater 3000 (MST3K)

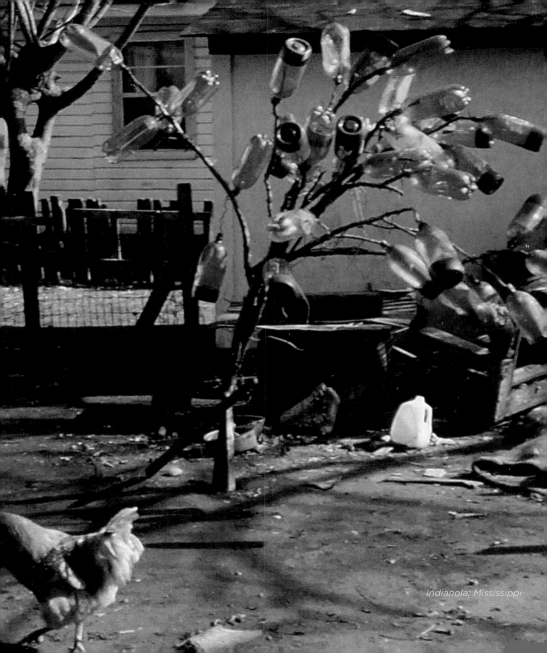

Indianola, Mississippi

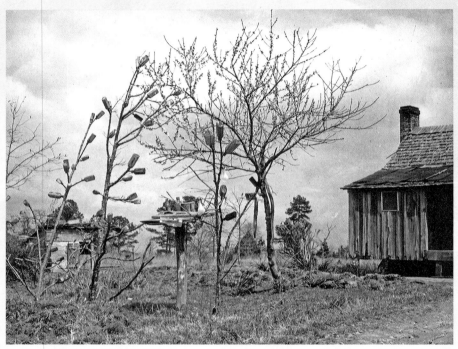

Simpson County, Mississippi, 1930s

"Out front was a clean dirt yard with every vestige of grass patiently uprooted and the ground scarred in deep whorls from the strike of Livvie's broom. Rose bushes with tiny blood-red roses blooming every month grew in threes on either side of the steps. On one side was a peach tree, on the other a pomegranate.

Then coming around up the path from the deep cut of the Natchez Trace below was a line of bare crape-myrtle trees with every branch of them ending in a colored bottle, green or blue.

There was no word that fell from Solomon's lips to say what they were for, but Livvie knew that there could be a spell put in trees, and she was familiar from the time she was born with the way bottle trees kept evil spirits from coming into the house – by luring them inside the colored bottles, where they cannot get out again.

Solomon had made the bottle trees with his own hands over the nine years, in labor amounting to about a tree a year, and without a sign that he had any uneasiness in his heart, for he took as much pride in his precautions against spirits coming in the house as he took in the house, and sometimes in the sun the bottle trees looked prettier than the house did..."

from Eudora Welty's short story, *Livvie*

Students of American glass

must always keep in mind

that the creations they collect

are truly examples of our

American culture... and thus

have historical significance.

James Lafferty

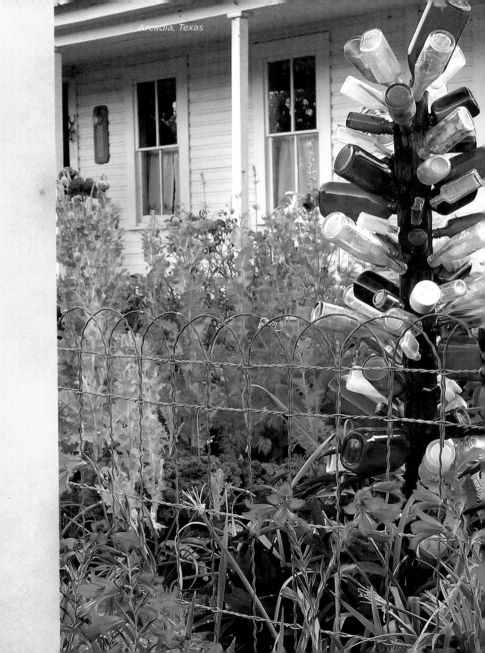

Arcadia, Texas

My quest for garden glass would have never been complete without a pilgrimage to Elmer Long's astounding Bottle Tree Ranch in California's Mojave Desert.

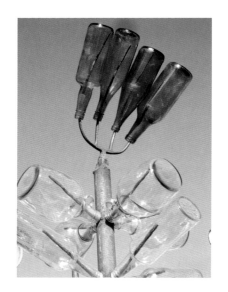

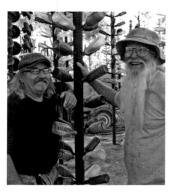

Driving along a dusty stretch of historic Route 66 just west of Barstow, without a clue how to find this homespun wonderland, I was gob-smacked by rows upon tight rows of metal "trees" – hundreds of them, each topped with a curious "found object" and festooned with colorful glass bottles. Late in the day they scattered the desert's setting sunlight into fiery magic.

On another visit, Elmer, who started the sculptures as a way to fill free time and further his father's antique bottle collection – and who cheerfully welcomes visitors from all over the world – shared cups of coffee and bits of desert history with me. When I wondered aloud how such a lucid thinker must feel, being so celebrated, but mostly for his eccentric creations, he and his sweet, patient wife Linda just smiled.

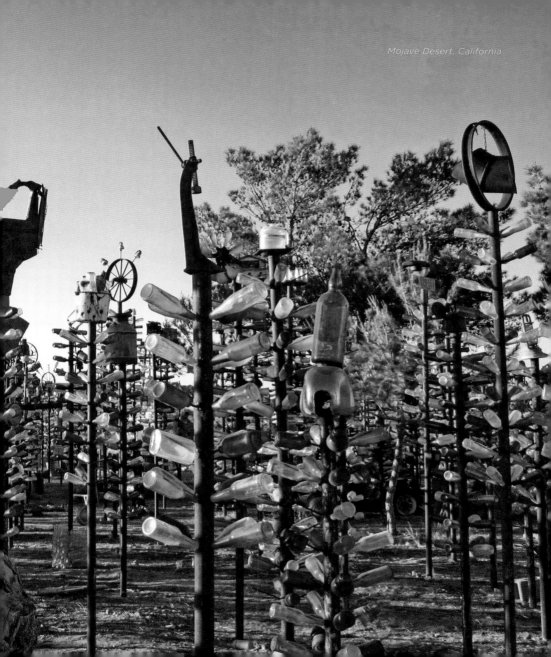

Mojave Desert, California

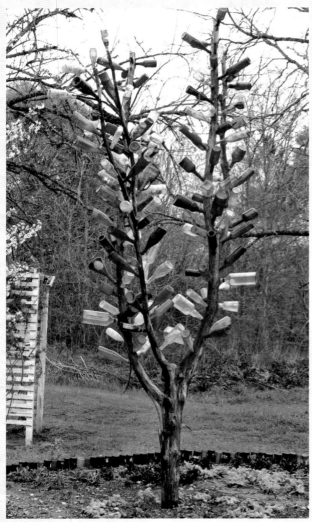

Round Top, Texas

Branches
extended
skyward,
the bottle tree
waves a
stained-glass
greeting.

Diane Fletcher

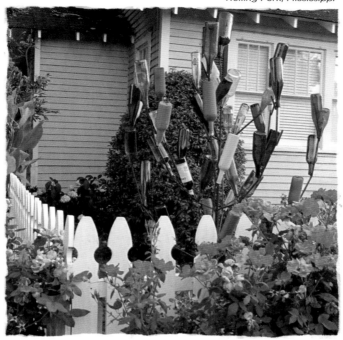

Sun glinting on glass
bright shadows color tall grass
These flowers don't fade

William Jerry Strowd

are bottle trees tacky??

After one of my garden art presentations at a prestigious flower show, a woman approached me and sniffed, **"To tell the truth, I think bottle trees are a bit tacky..."**

In one of the few moments in my life where I not only had a quick rebuttal, but also lost my upbringing and actually said it, I pointed out that the woman was wearing colorful ornaments as earrings.

Taken aback, she said, "I beg your pardon?" To which I replied, "That's right – you hang stuff out of holes in your ears, I hang bottles in my trees. We're even."

In the vein of "art is in the eye of the beholder," there is a proud but tacit difference between tacky and gaudy. As a friend once put it, "Gaudy is when you do something other people don't really like, but they cut you some slack because they think you know what you are doing. Tacky is when you just don't know any better, bless your heart!"

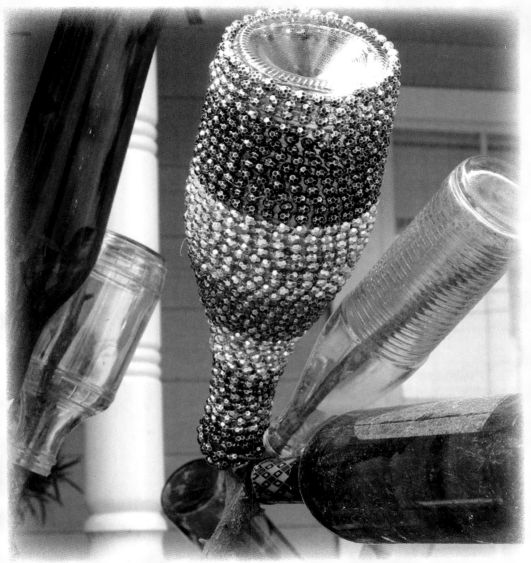

Bay St. Louis, Mississippi

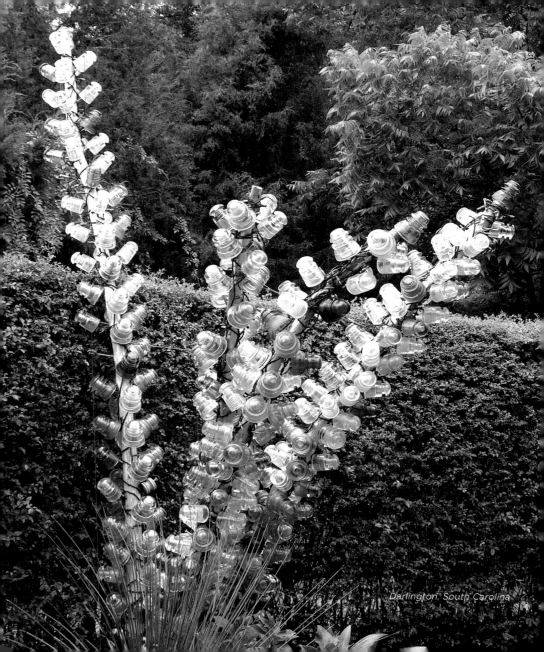

Darlington, South Carolina

Something odd I have noticed when talking with people who accessorize their gardens: Whereas "plastic pink flamingo" people tend to feel a camaraderie of sorts, as if they were helping one another take a stand against conformity, bottle tree people – even when there are several in the same neighborhood – see themselves as unique individuals just doing their thing.

In his garden every man may be his own artist without apology or explanation. Each within his green enclosure is a creator, and no two shall reach the same conclusion...

Louise Beebe Wilder

Chelsea Flower Show,
London, England

If there were ever a place to laugh,

it is in a garden.

To suddenly come across an amusing piece

placed among vegetation or by the side

of a pool is always a great bonus.

English designer John Brookes

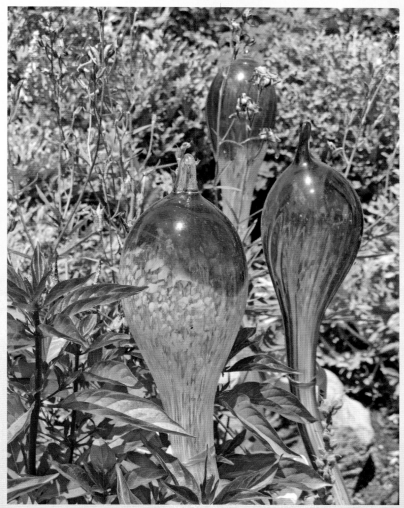

Tomball, Texas

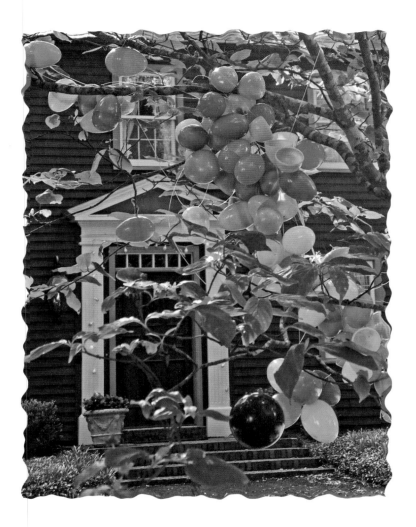

Even non-gardeners get into the swing of things, at least for a few weeks, with seasonal or holiday whimsies. Hardly a neighborhood in the country isn't graced for at least a few weeks with trees festooned for Easter, Christmas, Halloween, or the Fourth of July. Who can resist an opportunity to whoop it up by dangling funky stuff from branches?

People of the
common Level of
Understanding
are principally
delighted with
the Little Niceties
and Fantastical
Operations of Art,
and constantly think
that finest which is
least Natural.

Alexander Pope, 1713

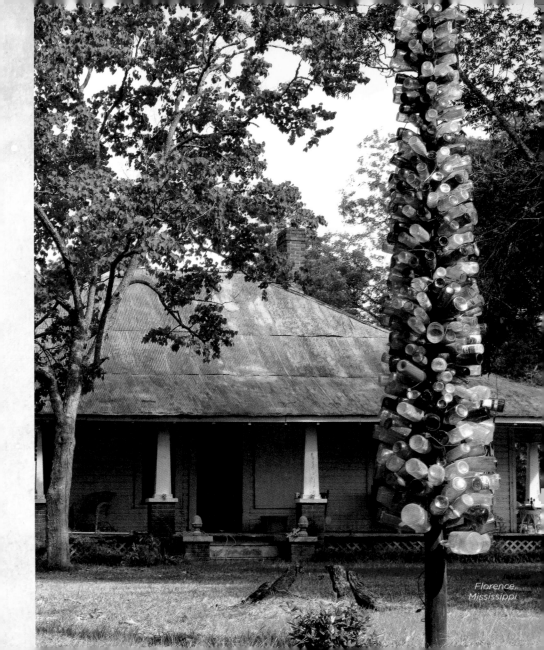

Florence,
Mississippi

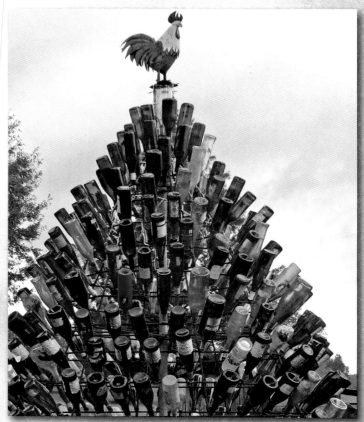

Cleary Lake, Mississippi

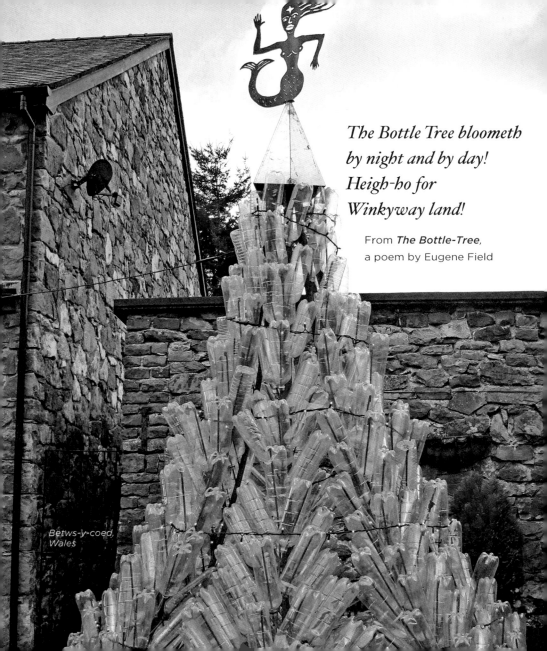

*The Bottle Tree bloometh
by night and by day!
Heigh-ho for
Winkyway land!*

From *The Bottle-Tree*,
a poem by Eugene Field

Betws-y-coed,
Wales

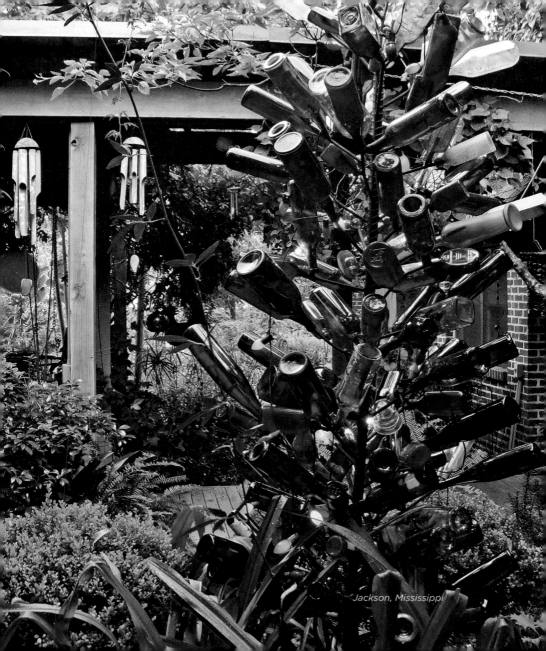

Jackson, Mississippi

I used to think art had no function, not like a sprinkler or arbor. But it can have – **color**, **texture**, **contrasts**. Like using a solid scarf or belt with a patterned dress. It's color, where there was none, in a shade garden. It's shiny, like a gazing globe or bottle tree...

Landscape Architect Rick Griffin

They who are all
things to their
neighbors cease
to be anything
to themselves.

Norman Douglas

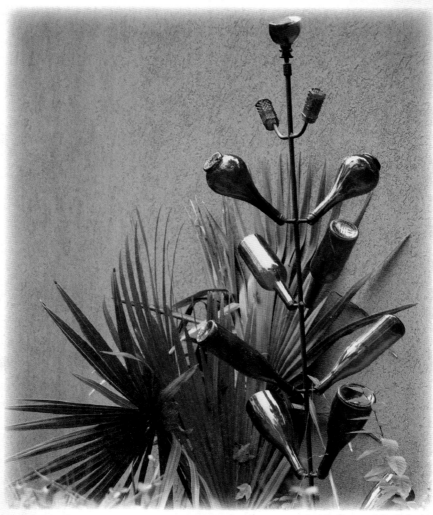

Belhaven , Mississippi

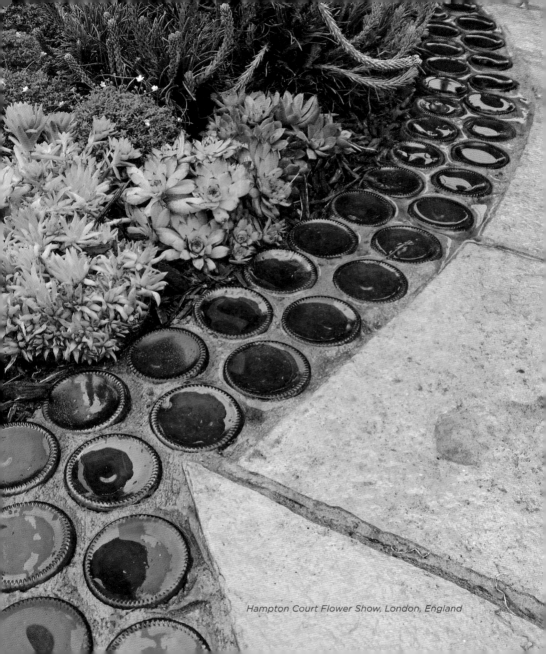

Hampton Court Flower Show, London, England

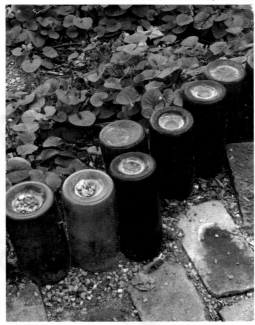

*Durable glass wine bottles, sunk
neck-down, make stunning borders for
flowerbeds and walks. Even after dusk they
reflect moonlight or any nearby source of light.*

The warrior of light
Knows that he is free
to choose his desires
And he makes those decisions
with courage, detachment,
and – sometimes –
with just a touch of madness.

Paulo Coelho

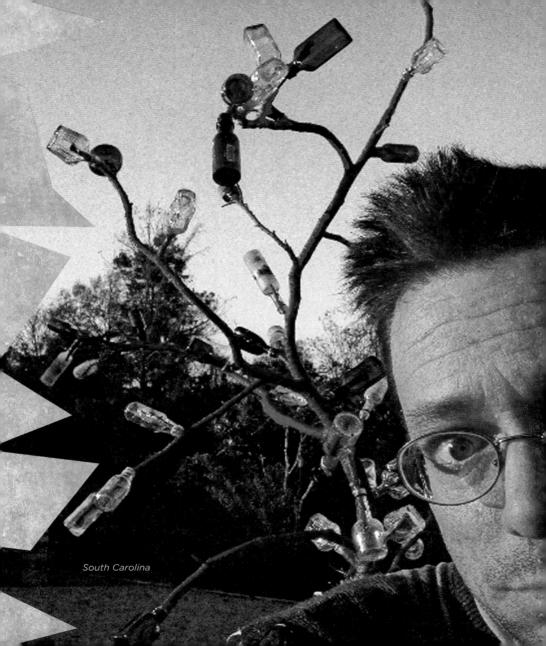

South Carolina

Are Bottle Trees Pagan?

Because of their connection to pagan superstition, there are folks who refute the use of bottle trees.

That dogged stance in itself seems a bit superstitious, much along the lines of how we think twice about walking under ladders, black cats crossing paths, and stepping on sidewalk cracks. Most of us really don't succumb to these unfounded beliefs, but they still give us pause. Truth is, many icons of modern-day customs, ceremonies, and religious holidays – including the hallowed Christmas tree – have origins in long-past pagan rituals.

Still, to most folks, bottle trees are just pretty garden ornaments. No more, no less.

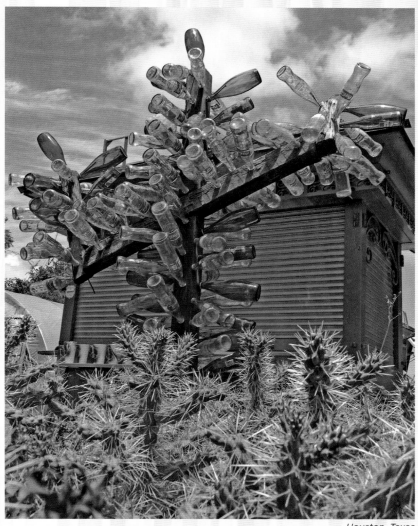

Houston, Texas

You use a
glass mirror to
see your face;
you use works
of art to see
your soul.

George Bernard Shaw

You don't have to be a professional in order to bring art into the care of your soul...

As the poets and painters of centuries have tried to tell us, art is not about the expression of talent or the making of pretty things. Art captures the eternal in the everyday, and it is the eternal that feeds the soul – the whole world in a grain of sand...

Thomas Moore, from *Care of the World's Soul*

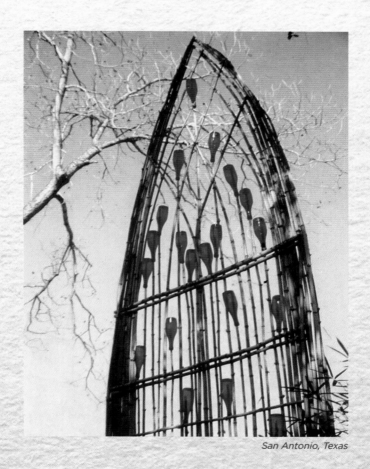

San Antonio, Texas

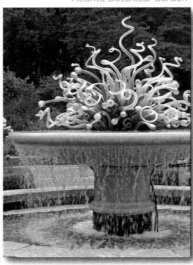

Atlanta Botanical Garden

Whenever I mention the name Dale Chihuly, whose uber-creative glass art I have photographed from coast to coast and overseas, audiences gasp in familiar acknowledgment of his incomparable work. The Seattle native is without a doubt America's — perhaps the world's — premier outdoor glass artist.

Chihuly and his assistants have brought garden glass to the mainstream. His fantasy creations — once described as "glass vegetation giving God's handiwork a run for its money" — have appeared world-wide in hundreds of art museums, garden conservancies, parks, pools, and aquariums, including the mind-boggling Chihuly Garden and Glass museum in the heart of Seattle.

I sometimes tongue-in-cheekily call homemade bottle trees "poor man's Chihuly." Truth is, if you were to set Chihuly's glass art one end of an imaginary glass art bell curve, and homemade bottle trees at the other end, between the two everything else seems perfectly normal.

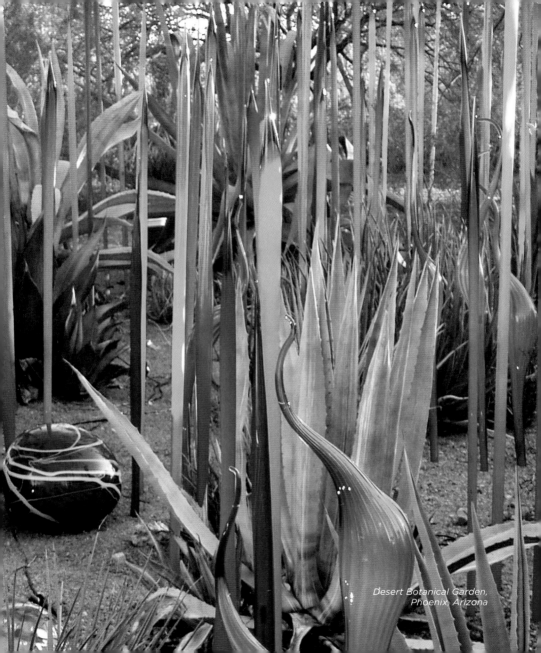

Desert Botanical Garden,
Phoenix, Arizona

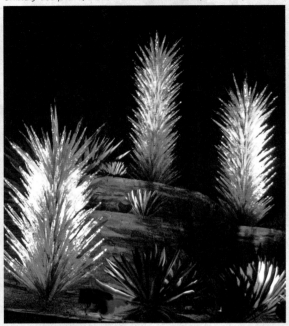

PEOPLE ARE LIKE STAINED-GLASS WINDOWS.
THEY SPARKLE AND SHINE WHEN THE SUN
IS OUT, BUT WHEN THE DARKNESS SETS IN,
THEIR TRUE BEAUTY IS REVEALED ONLY IF
THERE IS A LIGHT FROM WITHIN.

Elisabeth Kubler-Ross,
Swiss-American psychiatrist and author

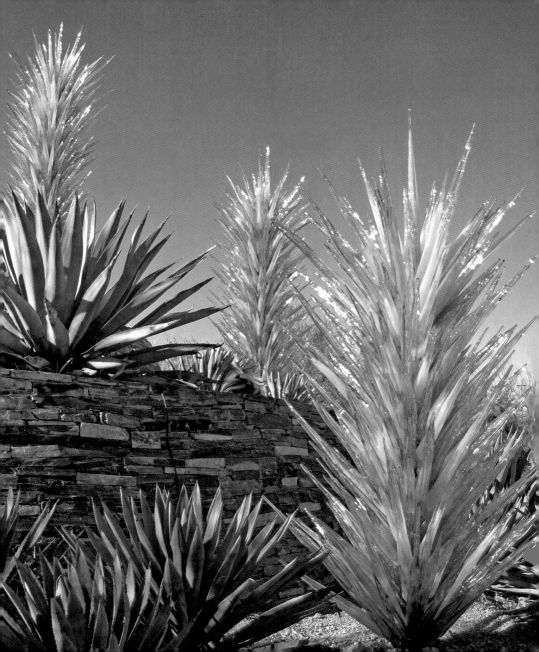

The first time I laid eyes on a bottle tree designed and built by metal artist Stephanie Dwyer, it caused me to immediately declare that she had put the "art" in yard art.

When she first moved her metal craft business from Seattle to Mississippi to be closer to some of her family, an aunt asked her to make a bottle tree. To get some ideas, she drove around looking at them in peoples' gardens. "The first few I saw didn't speak to me," she said, "They had no soul."

So she started designing highly stylized, powerful yet feminine versions, along with gates, entry arbors, outdoor chandeliers and more, all with her trademark swirls, iron leaves and balls.

My own garden now includes two of her bottle trees, an entry arbor, the fanciful stand for my outdoor grill, and even the highly stylized "burglar bars" around my cabin.

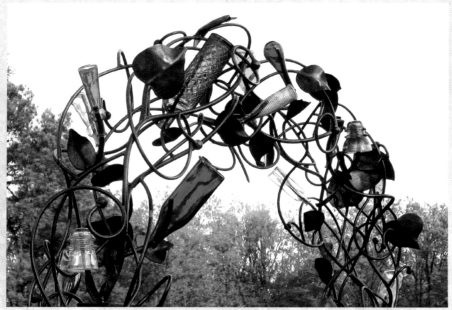

Pelahatchie, Mississippi

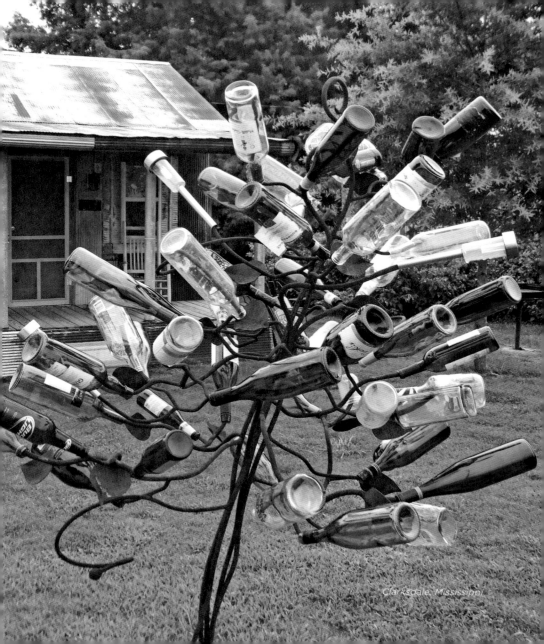
Clarksdale, Mississippi

There are quite a few people now making bottle trees for sale through garden centers and online mail order. Most simply cut and weld metal bars into various shapes on sturdy stands, and offer bottles as extras.

While some folks think bottle trees are mostly Southern icons, one of the most prolific bottle tree makers lives in the upper Midwest. One hot summer day my brown dog and I made a long-haul trek to central Wisconsin to visit Jerry Swanson, whose custom-designed, mail-order Bottle Tree Creations have been "planted" in over 41 states. Jerry's eyes shine when he describes how his trees endure glitter on frosty mornings; he sometimes changes the bottle colors as the seasons and holidays change.

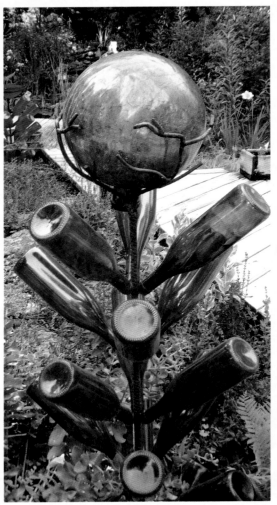

Princeton, Wisconsin

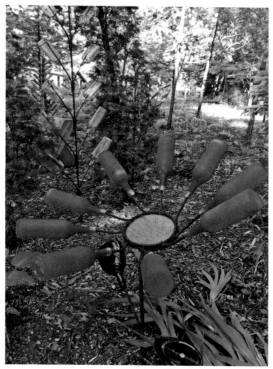

Princeton, Wisconsin

The usual lawn expresses nothing
so much as a vacancy of mind or an
impious waste of good material;
whereas **in a garden any man may be
an artist**, may experiment with all the
subtleties or simplicities of line, mass,
color, and composition, and taste the
god-like joys of the creator.

H. G. Dwight, "Gardens and Gardening," Atlantic Monthly, 1912

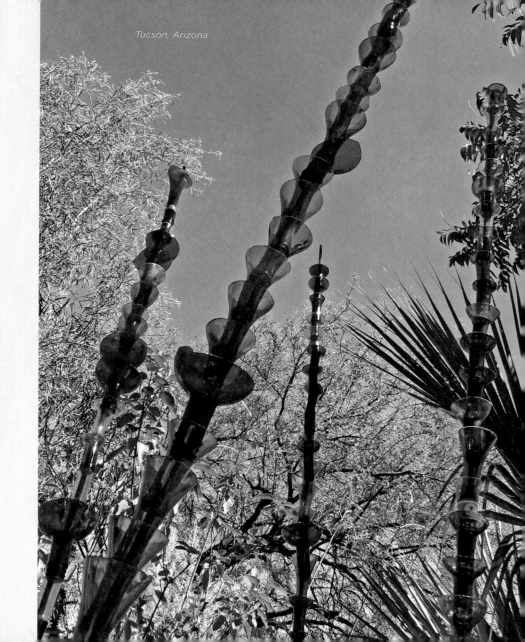

Too much
of a good thing
is wonderful

Mae West

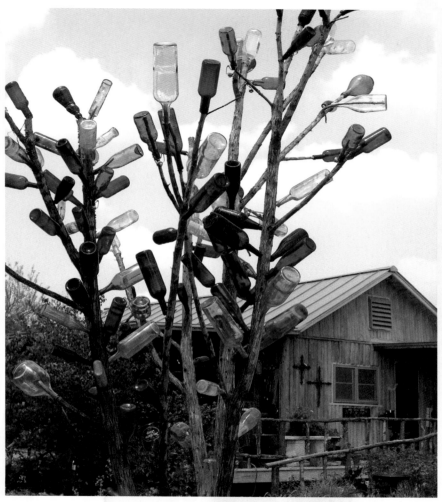

San Antonio, Texas

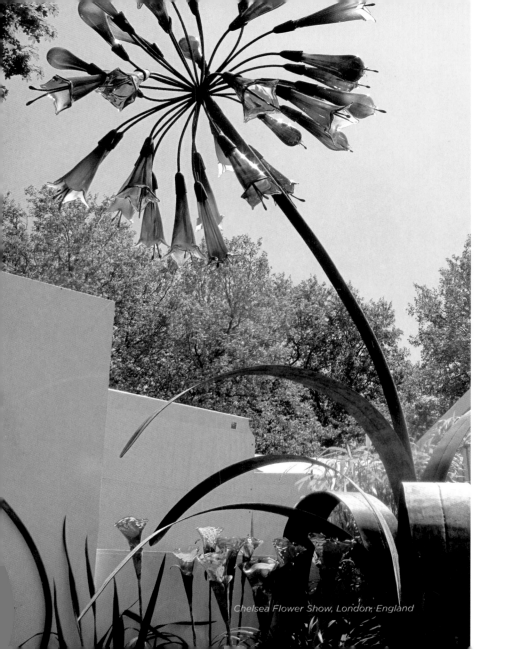

Chelsea Flower Show, London, England

Jenny Pickford, recognized as England's leading female artist blacksmith, combines forged steel with spectacular blown glass. Her unique, often oversized yet sensuous and feminine sculptures are carefully sited to work in total harmony with their garden surroundings.

After meeting her and photographing her stunning work in several gardens across England, I visited her studio in rural Herefordshire to see first hand how she creates her dramatic designs, and to get a feel for what motivates her.

As she puts it, "The softness and fragility of glass against the weight and strength of the metal reflect the contradictions we see in the natural world and also within ourselves."

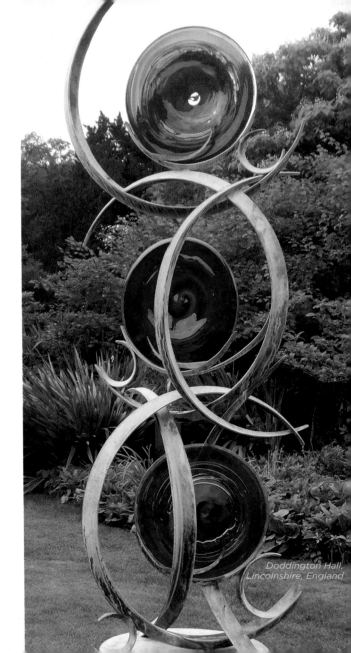

Doddington Hall, Lincolnshire, England

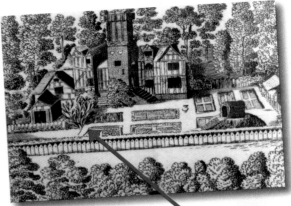

Tell me this isn't evidence of an early European bottle tree!

While researching a well-preserved medieval garden at an English manor, I found an original, highly detailed line drawing of the grounds made in the 1650's – with an accent plant looking like no other plant I have ever seen… no fruit, no leaves look just like this.

It looks exactly like a Jenny Pickford bottle tree installed in another nearby manor. **What do YOU think?**

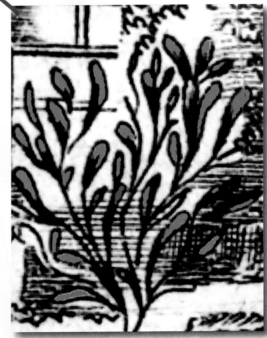

Boscobel Hall, Shropshire, England, ca 1650

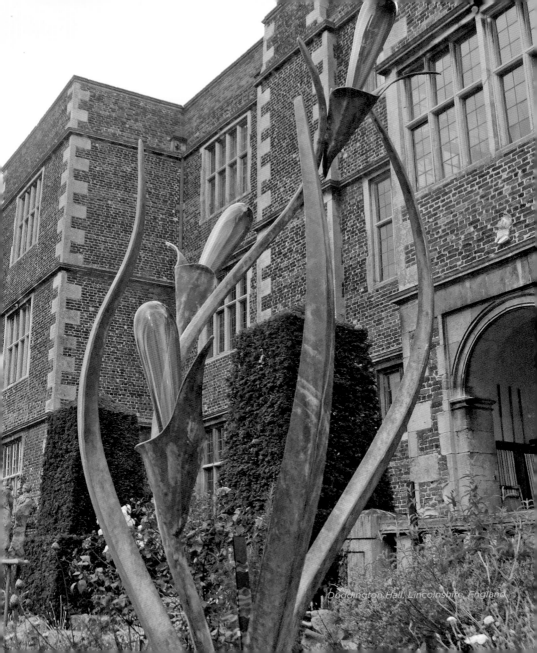

Doddington Hall, Lincolnshire, England

The garden can come alive after dusk with night lighting –
but why stick with the same old, same old light kit, when
local glass artists can help you create **fantasy**?

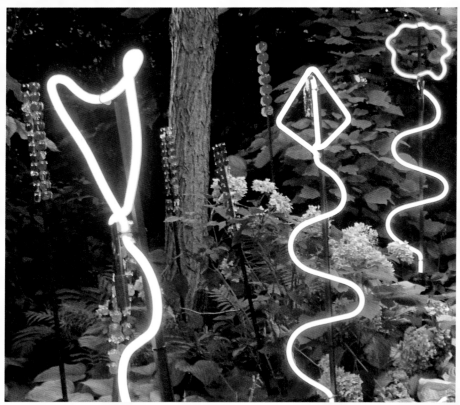

Neon Garden Art by Simple, near Philadelphia, Pennsylvania

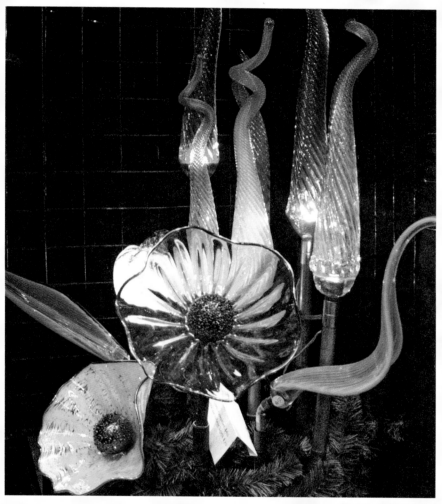

Seattle night lighting

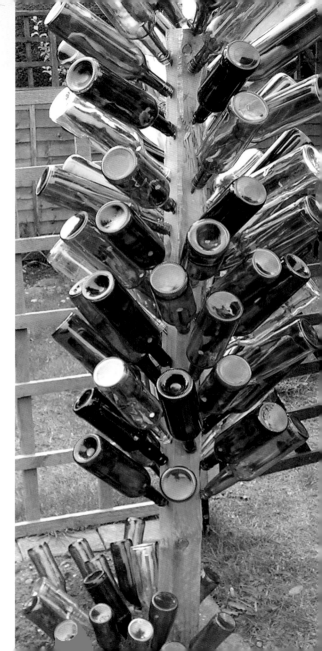

*Inspired by an article
in Garden News
last year, I have
created my own
bottle tree. It took a
long time to acquire
sufficient bottles as
I am a non-drinker."*

Kay Cozens
Lincolnshire, England

Kay Cozens' Bottle Tree

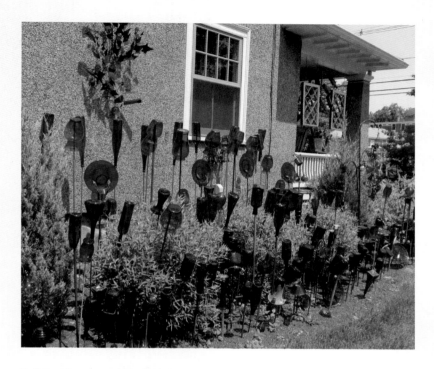

I found a woman in my town who has a bottle garden... started when her mom, who lives in England, sent her the 22 bottles she had when she moved. She said it's a very English tradition...

Alison Campbell, Bedford, Massachusetts

Cold hearted orb that rules the night,
Removes the colors from our sight.
Red is grey and yellow white,
But we decide which is right.
And which is an illusion?

from Late Lament, *Days of Future Passed*,
by the Moody Blues

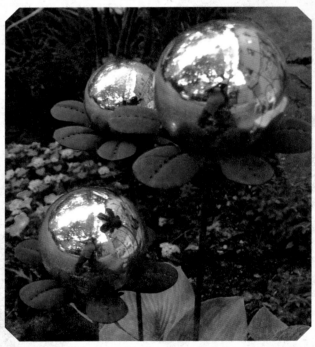

Florence, Mississippi

Don't tell me
the moon is shining;
show me the glint
of light on broken glass.

Anton Chekov

Clarksdale, Mississippi

Ft. Lauderdale, Florida

GAZING GLOBES

Gazing globes originated in 13th century Venice, where skilled Italian artisans crafted them out of mouth-blown glass. Fifteenth century priest Antonio Nier referred to them as Spheres of Light, and legends formed about the mysterious powers of the ball, which purportedly brought happiness, good luck and prosperity to those who owned one. The globes were also known to ward off evil spirits, misfortune, illness and even witches.

King Ludwig II of Bavaria adorned his palace with them, and they soon became a fixture of European gardens. Francis Bacon stated that a "proper garden should have rounded color balls for the sun to play upon."

When placed strategically beside garden paths, they allowed people to see visitors in time to prepare – or to hide. In Victorian times, "butler balls" were used by servants to see when diners needed assistance, without staring directly at people.

You can make your own gazing globe from a sanded, painted bowling ball stood in the garden on a stick of iron "rebar" (found in various lengths at builder supply stores). For more flair, you can even glue and grout glass shards and tiles.

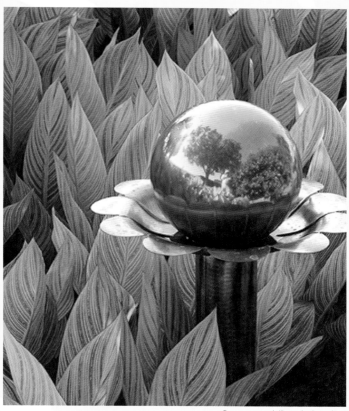

Greenwood, South Carolina

We can do a lot of things with plants, but truly great gardens – every case – have some sort of artwork to truly personalize them. *Your touch, in your space.*

Landscape architect Professor Neil Odenwald,
Baton Rouge, Louisiana

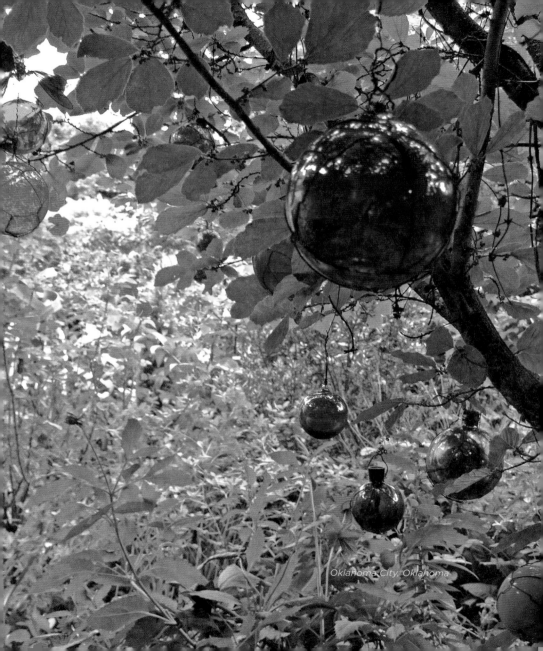

Oklahoma City, Oklahoma

Bottle Tree

MASHING HER THOUGHTS TOGETHER
LIKE LAST NIGHTS POTATOES
SHE STAYS TOO LONG IN THE PAST AGAIN
STARING AT NOTHING AND SEEING EVERYTHING
ANALYZING HER OWN WEAK CONDITION
BOTTLES WHISTLE AND SHINE ON THE TREE
COBALT INSTRUMENTS OF THE WIND
KEEPING AWAY THE TROUBLED SPIRITS

Tina Trivitt, Georgia poet

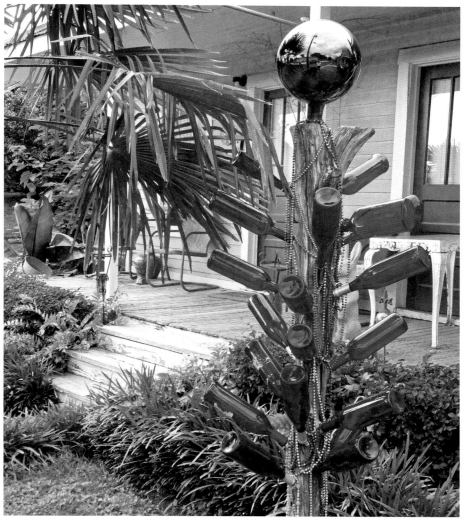

Natchez, Mississippi

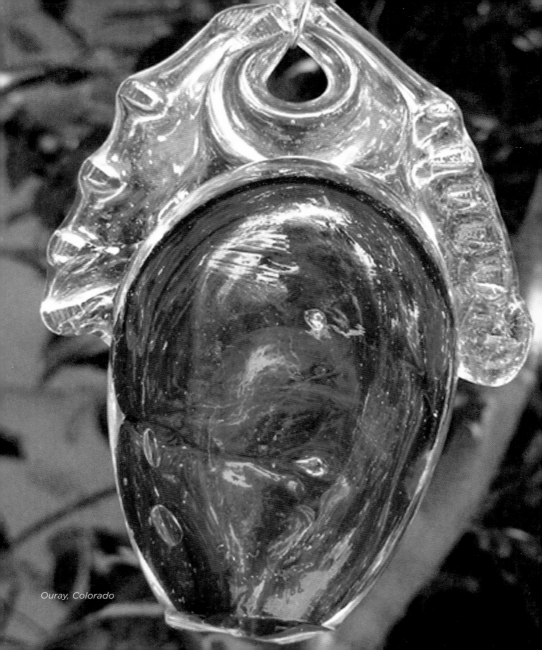

Ouray, Colorado

WITCH BALL

Small hollow spheres of plain or stained glass originated among cultures where so-called "witches" were considered a blessing. Witches would usually "enchant" the balls to enhance their potency against evils.

However, by the 18th century, Europeans commonly hung them in cottage windows to ward off evil spirits, witches' spells or ill fortune. The word witch ball may be a corruption of watch ball, because it was used as a guard against evil spirits. According to folk tales, witch balls would entice evil spirits with their bright colors; the strands inside the ball would then capture the spirit and prevent it from escaping.

The Genie in Aladdin's Lamp

Who doesn't know about the wish-granting genie in the magical lamp of Aladdin? The fantastic tale appears in *The Book of One Thousand Nights and One Night*, a French translation of a collection of ancient folk tales compiled in Arabic during the Islamic Golden Age.

Genies, or jinni, are a class of spirits that according to Muslim demonology inhabit the earth, assume various forms, and exercise supernatural power. After the French translators of the Arabic folk tales used *génie* as a translation of jinni, the English continued the tradition; their earliest written use appeared in 1655, in a plural spelled *genyes*.

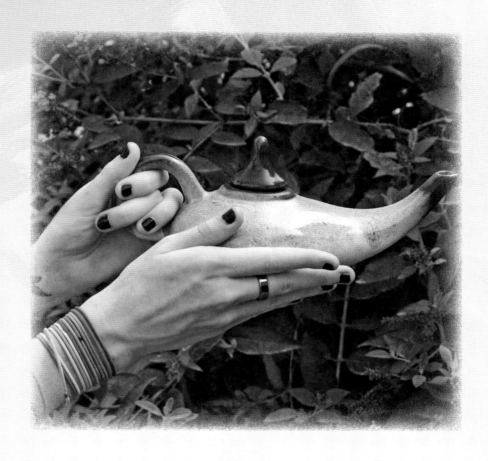

Cobalt Blue
favored for bottle trees,
named after German gnomes

The color of choice for bottle trees has long been blue. While most experts disagree on how, or even if, colors affect humans psychologically, many references agree that blue is a universally relaxing, calming color.

Ingots of cobalt glass over five thousand years old have been recovered from Minoan shipwrecks, and a cobalt blue

1st century A.D. Mediterranean cobalt glass art

Persian glass necklace has been dated to 2250 B.C. When Vesuvius blew itself to pieces in 79 A.D., it buried cobalt glass objects with their owners.

The name "cobalt" comes from the mountainous silver mining areas of medieval Germany. The earliest record of the word, first used in 1335 A.D., applied to mysterious mountain spirits called kobalds, thought to be causing respiratory problems in the miners — actually, not far from the truth, since cobalt dust releases arsenic during silver smelting, which would have caused the miners' respiratory ills.

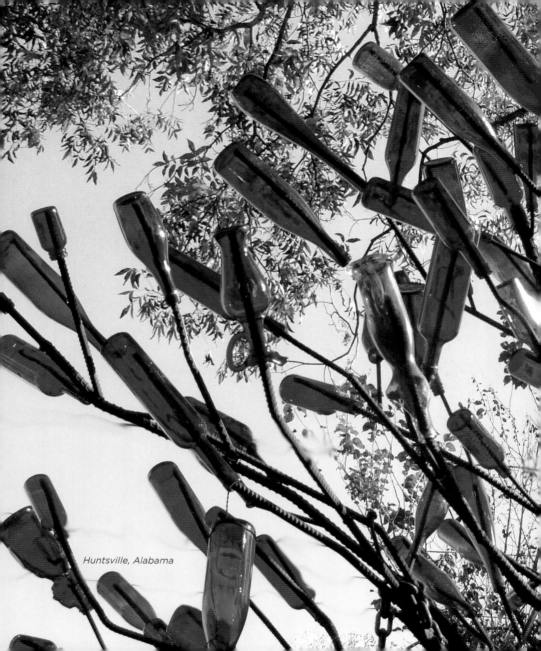

Huntsville, Alabama

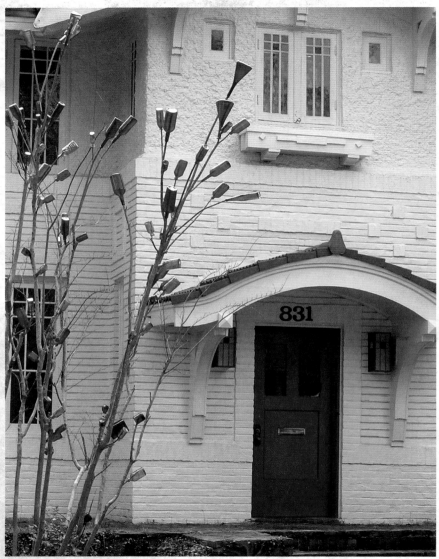

Jackson, Mississippi

Southern Dream Catcher

The bare broken branches hold up
their bayou lure, the haint blues
and the witch's cobalt ball the traps
of the southern dream catcher.

On a night the moon shuts tight
its quartered eye, white wisps writhe
like snakes inside colored bottles
balanced on welcoming arms.

Morning's shine on the crape myrtle
stills our breath-denying fear.

Maureen Doallas

Putting an artist's spin on what glass is about in the garden, Jenny Pickford, England's premier steel-and-glass garden artist, summed it up perfectly:

*We are simply holding glass up to the light, where it can **sing**...*

Color is my daylong obsession, joy and torment.

Claude Monet

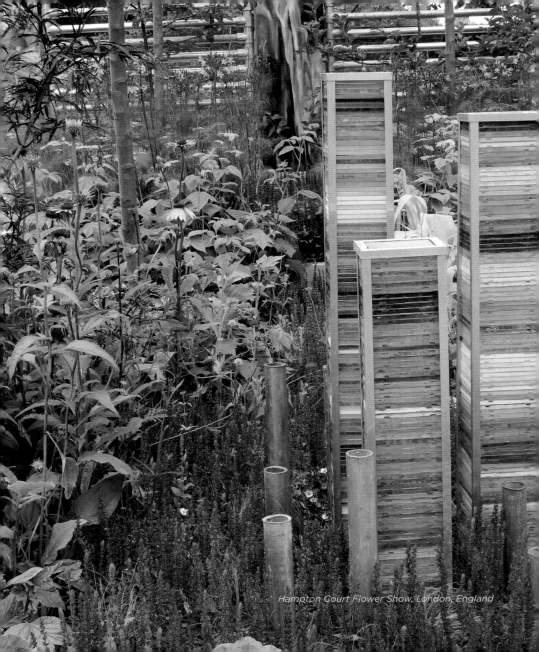
Hampton Court Flower Show, London, England

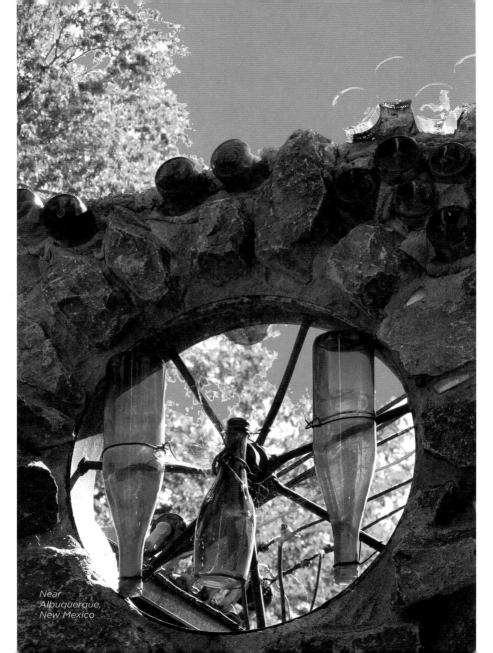

Near
Albuquerque,
New Mexico

There are some lives duller than dusty glass

Ishikawa Takuboku

Each glass bottle
determines what part
of the COLOR SPECTRUM —
Starlight from the Sun —
we actually see.

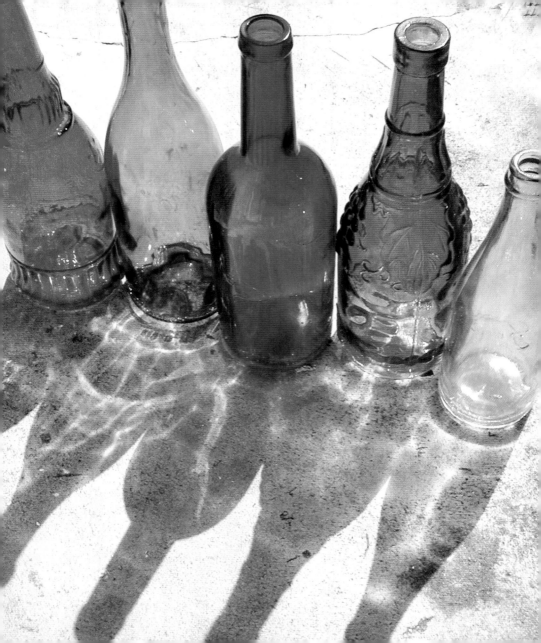

Homemade "glass" can be made using clear resin poured into a homemade mold. Add dried flowers, colorful bits of glass, tile, or even cloth, to create unique pieces to set amongst flowers.

Edinburgh, Scotland

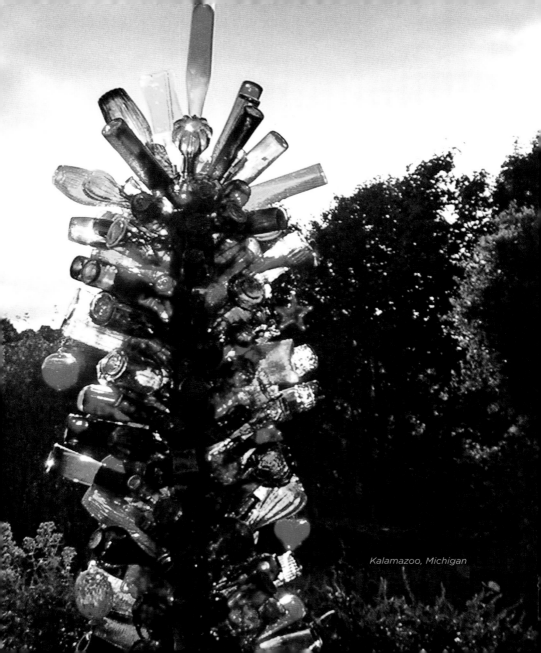

Kalamazoo, Michigan

Here to recompense
the loss of past
pleasures, and to
buoy up their hopes
of another Spring,
many have placed
in their Gardens,
Statues, and Figures
of several Animals,
and great variety of
other curious pieces of
Workmanship, that
their walks might be
pleasant at any time
in those places of
never dying pleasures.

John Worlidge,
Systema Horticulturae, 1677

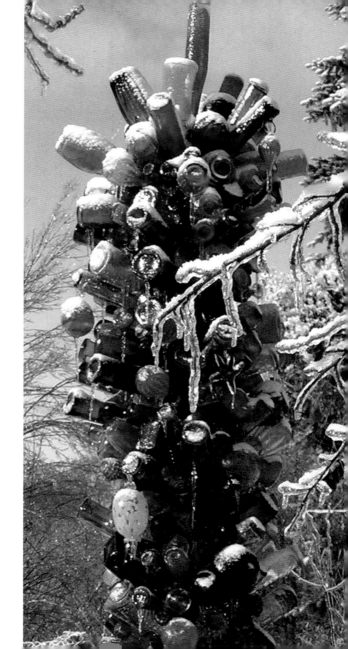

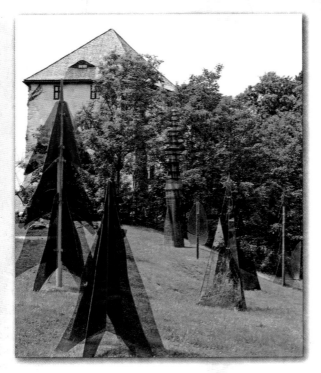

The Glass Forest

I made a special trek to Regen, Germany, in the mountainous heart of the Bavarian Forest, to wander amongst the largest glass trees on earth. The "Glass Forest" (Gläserner Wald), which is set beside picturesque 13th century castle ruins, was created by area glass artists to demonstrate the versatility and durability of glass in outdoor art installations. Some of the "trees" are over 25 feet tall, and were especially beautiful at sunset.

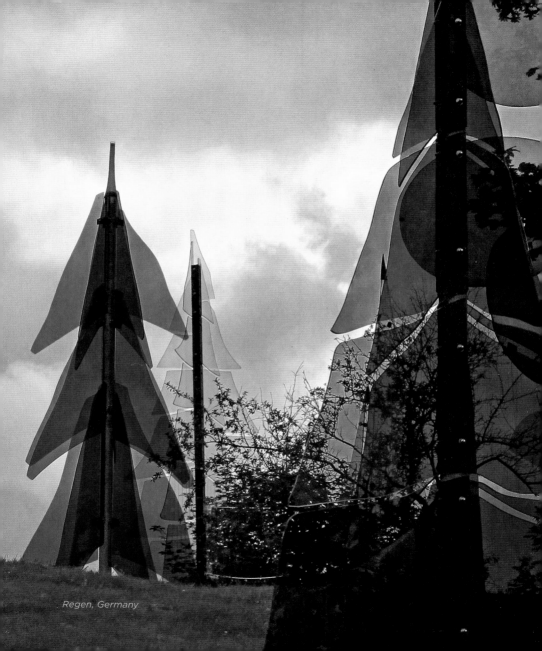

Regen, Germany

BETTER THAN

TRUTH TO MATERIALS

IS

TRUTH TO INTELLIGENCE.

Ian Finley, on the use of alternate media in art

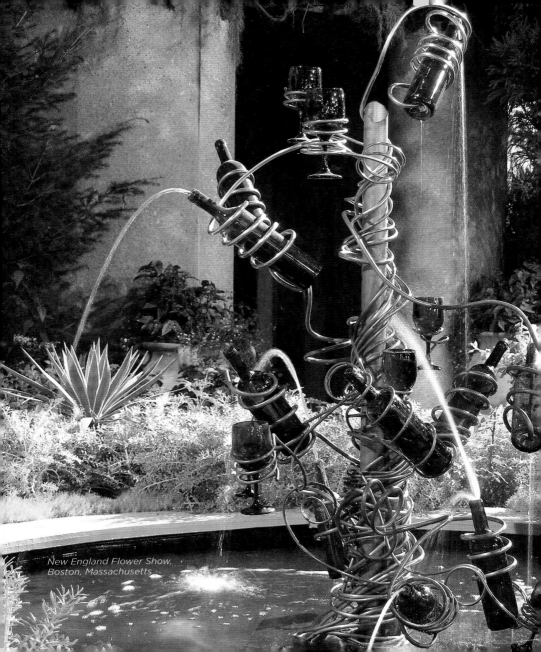

New England Flower Show,
Boston, Massachusetts

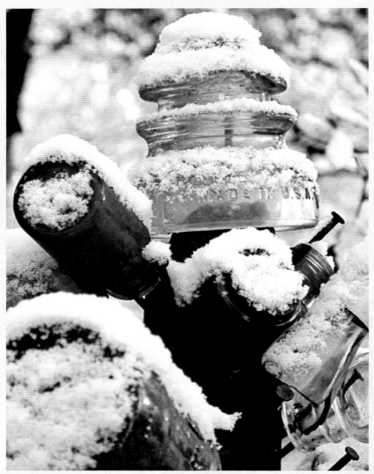

Author's winter garden

When Winter scourged the meadow and the hill
And in the withered leafage worked his will,
Then water shrank, and shuddered, and stood still,
Then built himself a magic house of glass,
Irised with memories of flowers and grass,
Wherein to sit and watch the fury pass.

Sir Charles George Douglas Roberts

In 2004 artist **Virginia Wright-Frierson** created the "Minnie Evans Sculpture Garden Bottle House" at Airlie Gardens in Wilmington, North Carolina, in honor of the hard-working visionary folk artist. The walk-in sculpture used bottles of all shapes and sizes, as well as cement and chicken wire, to recreate some of the images and symbols in Minnie Evans' work.

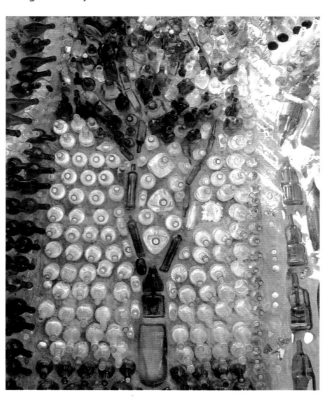

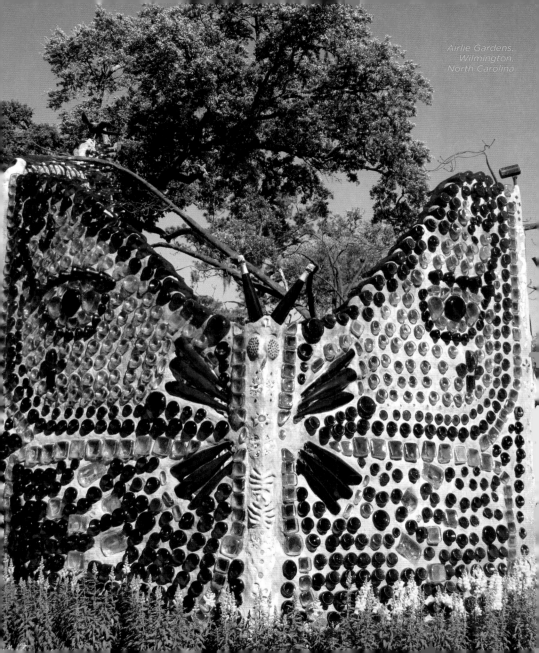

The work of art
is born of the
intelligence's
refusal to reason
the concrete.

Albert Camus

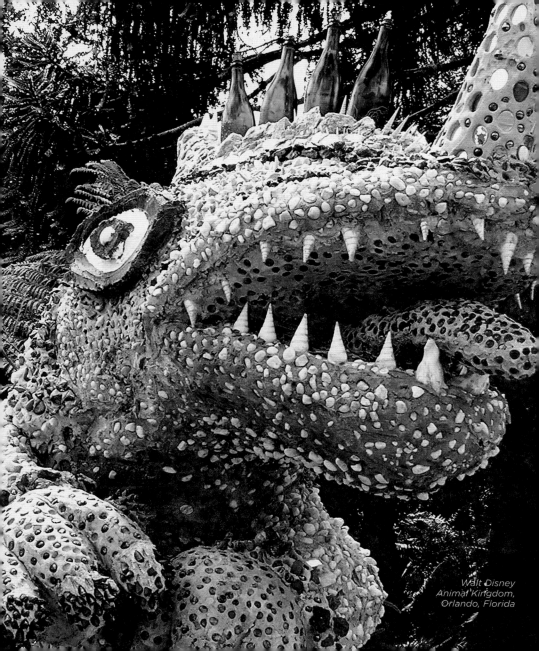

*Walt Disney
Animal Kingdom,
Orlando, Florida*

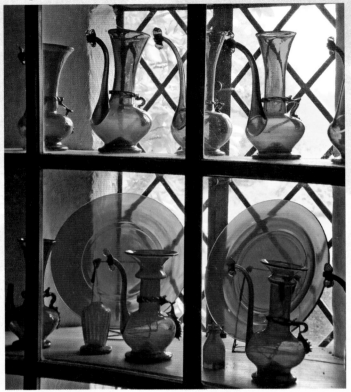

In mid-winter, colorful glass – even in windowsills –
can jazz up our stimulation-starved pineal glands
into producing hormones that help stave off
Seasonal Affective Disorder: the winter blues.

There is absolutely
nothing in the world
like a backyard with
bottle trees in winter,
when snow is on the
ground, and sunlight
slams that cobalt blue.
**It's nothing short
of dazzling.**
We're hungry for it
in mid-winter. A full
spectrum light helps
with the seasonal stuff,
but we also need
the color.

Marcia Eames-Sheavly

Ithaca, New York

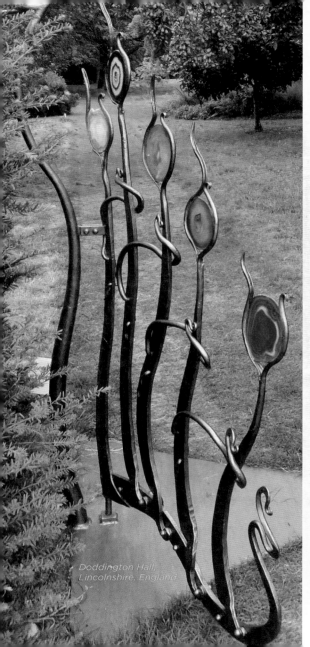

Doddington Hall,
Lincolnshire, England

A few strongly
marked objects,
either picturesque
or simply
beautiful, will
often confer their
character upon a
whole landscape...

Andrew Jackson Downing,
a tastemaker of
19th century garden design

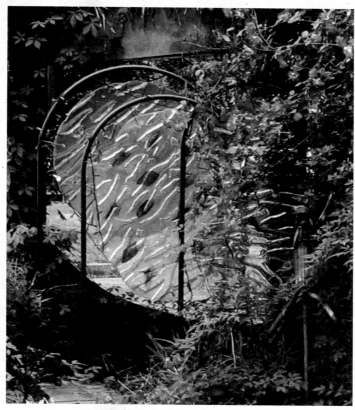

Andrew Young Sculpture, author's garden, Mississippi

They're nice to look at, but I wouldn't fancy one in **my** garden.

Celia Rushton, Darwen, England

Artificial tree with tiny glass flowers at the once-a-decade Floriade in the Netherlands.

as in all of the arts, the best garden designers take risks. only by taking risks can you come up with something exciting and original.

James Van Sweden

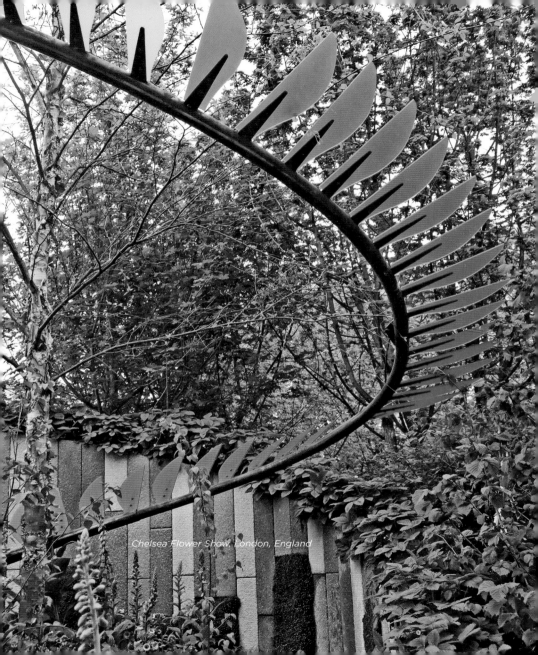

Chelsea Flower Show, London, England

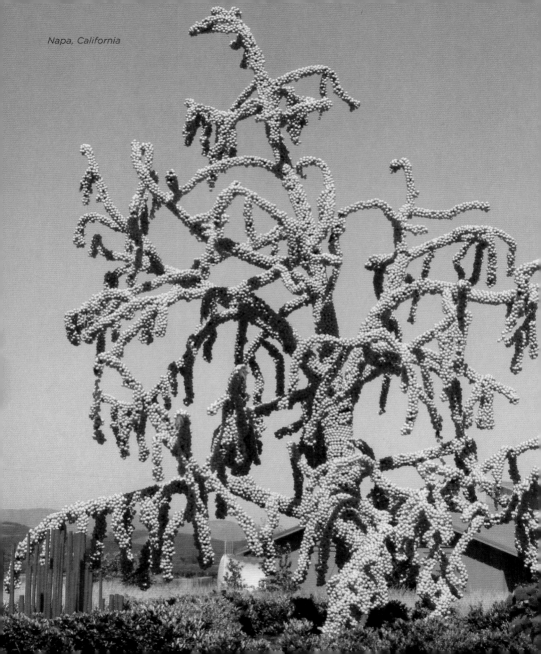

Napa, California

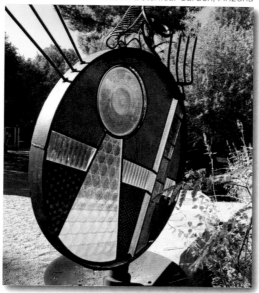

Tucson Botanical Garden, Arizona

*O*ne of the defining aspects of our species is that we make objects that are essentially non-utilitarian; **we make beautiful artwork because we find them pleasing to the eye and the soul.**

Some of that power is diminished when they are placed in a museum or gallery because they are out of context. Placing sculpture outdoors restores that power and that is why people will relate to them.

Simon Gudgeon

Glass is a thing in disguise,

an actor, is not solid at all, but a liquid. An old sheet of glass will not only take on a royal and purplish tinge but will reveal its true liquid nature by having grown fatter at the bottom and thinner at the top. It is invisible, solid, in short a joyous and paradoxical thing, as good a material as any to build a life from.

Peter Carey, from *Oscar and Lucinda*, ch.32, 'Prince Rupert's Drops'.

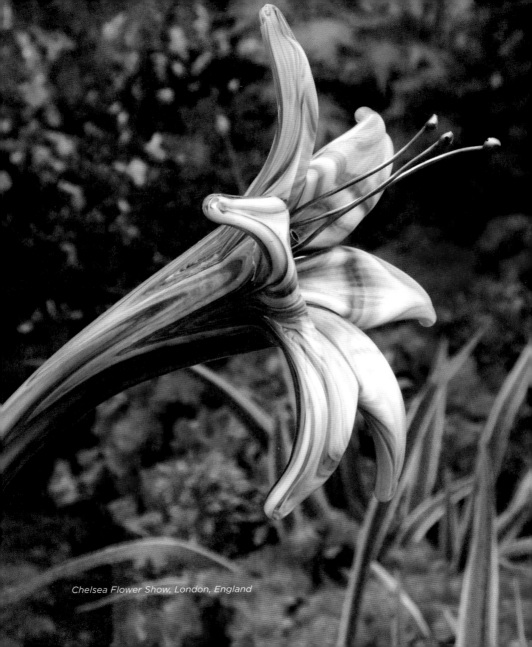

Chelsea Flower Show, London, England

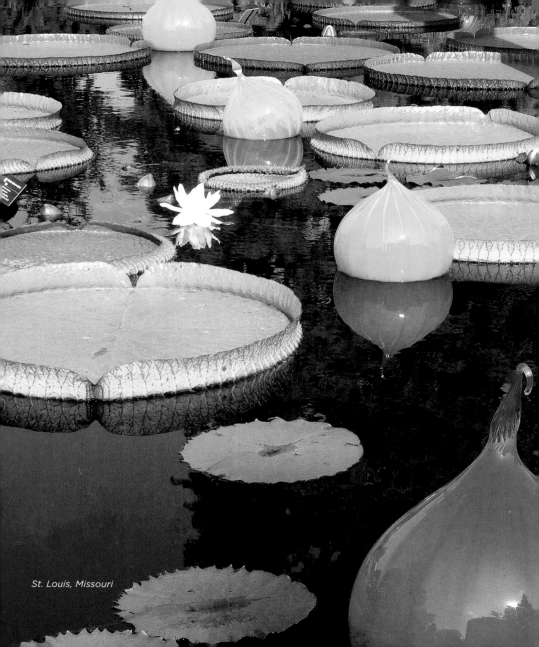

St. Louis, Missouri

There is a greatness in
all follies, a strength in
all extravagance...
How many people
can one number
whose minds are
ready to admit that
audacity in matters of
art is not necessarily
disingenuous?

Charles Baudelaire (French poet, 1821-1867)

Each of us

is carving a stone,

erecting a column,

or cutting a piece

of stained glass

in the construction

of something much

bigger than ourselves.

Adrienne Clarkson

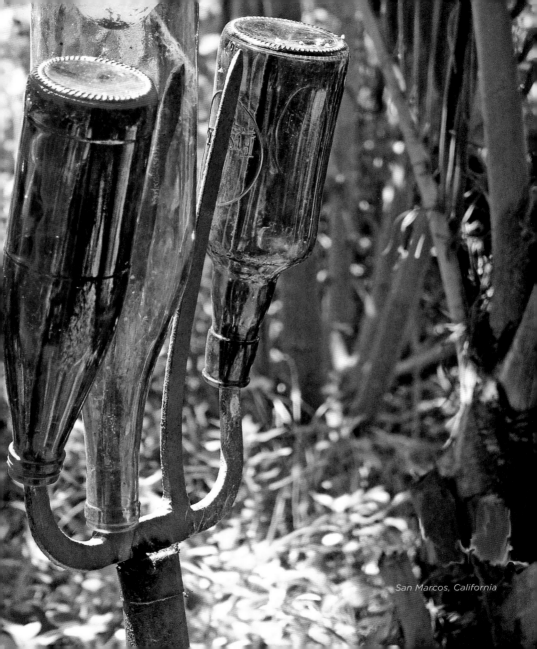

San Marcos, California

Michiana, Indiana

There is no 'high end' or 'low end' way to use glass in the garden – it's just a fun material to work with… You either love glass or you don't, but I think it's almost impossible to have a bad piece of glass.

It's all gorgeous.

Cindy Coldiron, author of
Sculpture and Design with Recycled Glass

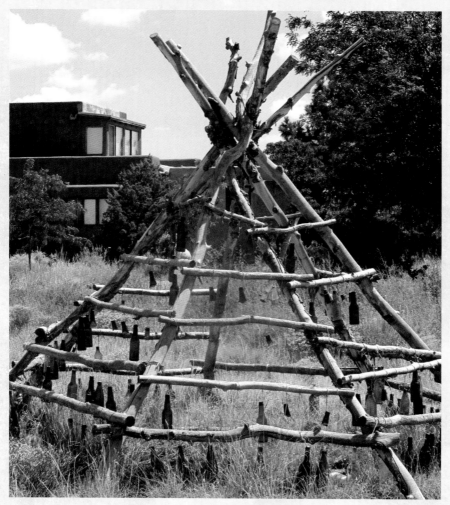

Nutt, New Mexico

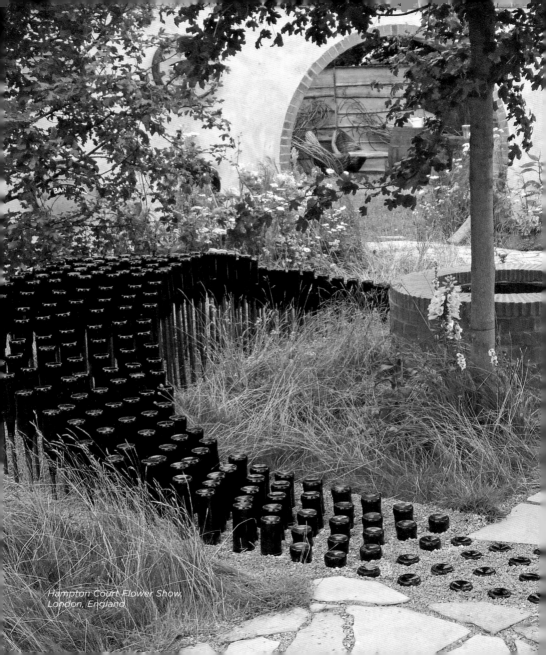

Hampton Court Flower Show,
London, England

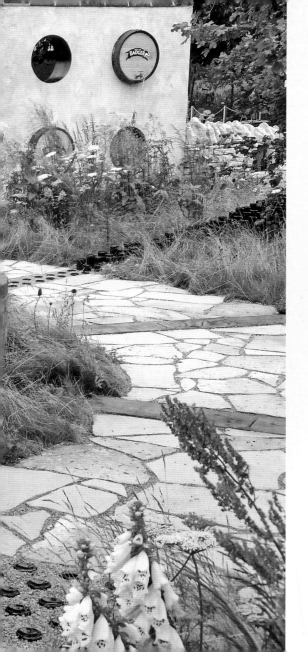

It isn't that I don't like sweet disorder, but it has to be judiciously arranged.

Vita Sackville-West

About the Author

\mathcal{F}elder Rushing is a 10th-generation American gardener who splits his time between puttering around a celebrated Mississippi cottage garden and living in a rural Crown farmhouse in the western Midlands of England. As the founder of the international Slow Gardening movement, he travels extensively across the U.S. and around the world, lecturing and seeking inspiration in the subtleties of gardens done just for the love of it.

Felder has written newspaper gardening columns for over 30 years and hosted or appeared in a number of TV garden programs. The garden-irreverent horticulturist is often featured in magazines and newspapers, including the *New York Times*, for his laid-back, "the rules stink" approach to gardening. Author or co-author of 18 gardening books and longtime host of a popular NPR-affiliate radio program, Felder has had countless articles and photographs published in gardening magazines, among which are *Fine Gardening, Horticulture, Garden Design, Organic Gardening, National Geographic, Better Homes and Gardens, Landscape Architecture*, and England's *Garden News*.

His garden observations and photographs can be found at

www.felderrushing.net